The
Birds
COLORING
BOOK

SIRIUS

SIRIUS

This edition published in 2023 by Sirius Publishing, a division of
Arcturus Publishing Limited,
26/27 Bickels Yard, 151–153 Bermondsey Street,
London SE1 3HA

Copyright © Arcturus Holdings Limited

ISBN: 978-1-3988-2600-7
CH011005NT
Supplier 29, Date 0123, PI 00003248

Printed in China

Index of plates

6–7 Blue jay	84–85 Long-eared owl
8–9 Dalmatian pelican	86–87 Golden eagle
10–11 Baltimore oriole	88–89 Townsend's warbler
12–13 Northern bullfinch	90–91 Mountain quail
14–15 Chestnut-backed chicadee	92–93 Hawfinch
16–17 Black-headed bunting	94–95 Carolina parrot or parakeet
18–19 Bay-breasted warbler	96–97 Savannah sparrow
20–21 Common kestrel	98–99 American redstart
22–23 Violet-green swallow	100–1 Steller's jay
24–25 Harris's buzzard or Harris's hawk	102–3 Connecticut warbler
26–27 American avocet	104–5 Common kingfisher
28–29 Swallow-tailed flycatcher	106–7 Norther fulmar
30–31 Pelagic cormorant	108–9 Griffon vulture
32–33 Rose-coloured starling	110–1 Blue-throated warbler
34–35 Roseate spoonbill	112–3 Greenfinch
36 37 Waxwing	114–5 Passenger pigeon
38–39 Dickcisseel	116–7 White-throated kingfisher
40–41 Pine grosbeak	118–9 Painted bunting
42–43 Western tanager	120–1 Two-barred crossbill and white-winged crossbill
44–45 Common redstart	122–3 Great blue heron
46–47 Great gray owl	124–5 Purple heron
48–49 Common buttonquail	126–7 Cerulean warbler
50–51 Yellow-throated warbler	128–9 Brandt's jay
52–53 Azure-winged magpie	130–1 Red-throated loon
54–55 Red-shouldered hawk	132–3 Golden oriole
56–57 Scarlet tanager	134–5 Barred owl
58–59 Belted kingfisher	136–7 Greater flamingo
60–61 Common wood pigeon	138–9 Blue grosbea
62–63 Carolina wren	140–1 American goldfinch
64–65 Green-backed purple gallinule	142–3 Summer tanager
66–67 Green-breasted mango hummingbird	144–5 Northern cardinal
68–69 Common redpoll	146–7 Yellow-billed magpie
70–71 Eastern bluebird	148–9 Lazuli bunting
72–73 Caucasian great rosefinch	150–1 Horned puffin
74–75 American flamingo	152–3 Red-rumped swallow
76–77 Green woodpecker	154–5 Northern shoveler
78–79 Red-breasted sapsucker	156–7 Firecrest
80–81 White-backed woodpecker	158–9 Rough-legged hawk
82–83 Blue-gray gnatcatcher	

Introduction

Birds have always been a source of fascination—
not only to naturalists, but also to those of us
who just like to watch their activities and
admire their beauty. They are wonderful
subjects to paint and draw, too, but
difficult if you are not an experienced
artist. You can photograph birds so
you can study them at leisure, but
finding out how to portray feathers
and colors so that you can make them
come alive on paper is another matter.

The answer is to learn from artists of
the past, discovering how they captured
the essence of the birds they painted.
The plates in this book are taken from
A History of the Birds of Europe (1871) by
H. E. Dresser and *The Birds of America* (1840–44) by John T. Bowen and
John James Audubon. In the days before photography came of age,
accurate, detailed paintings were the only way to provide a visual record
of a species—but the artistry of Audubon's work rose far above a careful
depiction of the subject for the benefit of scientists and appealed to the
general public curious to know about the natural world.

Audubon often worked with watercolor, combining it with pastel to
render the texture of feathers. You may find it easier to start with colored
pencils. By blending them you will be able to achieve the rich colors of the
plates—but take care to follow the direction of the feathers as you work. The
delight of a coloring-in book is that you can get straight into applying colors
without worrying about your drawing skills, safe in the knowledge that the
outlines and features of your birds will look true to life.

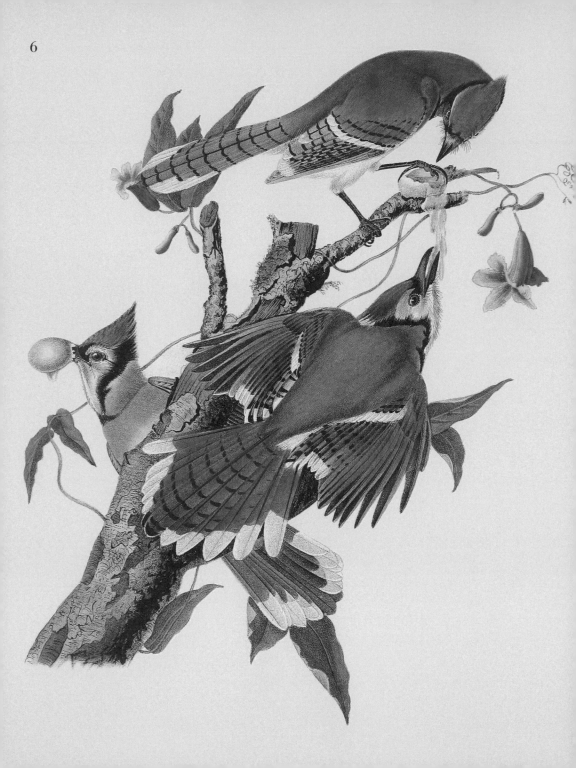

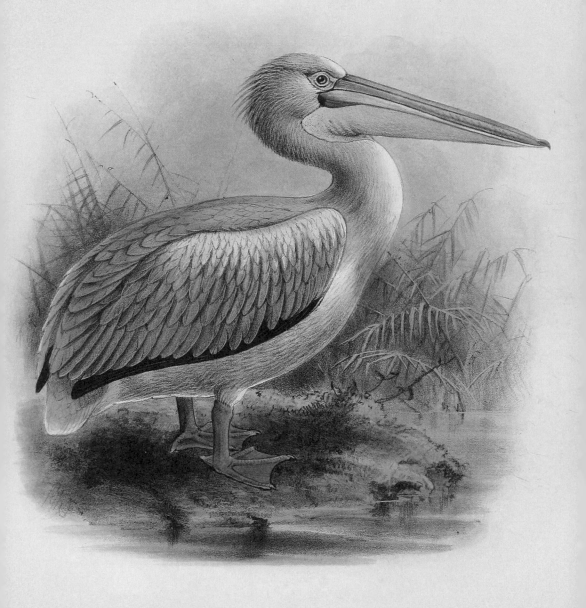

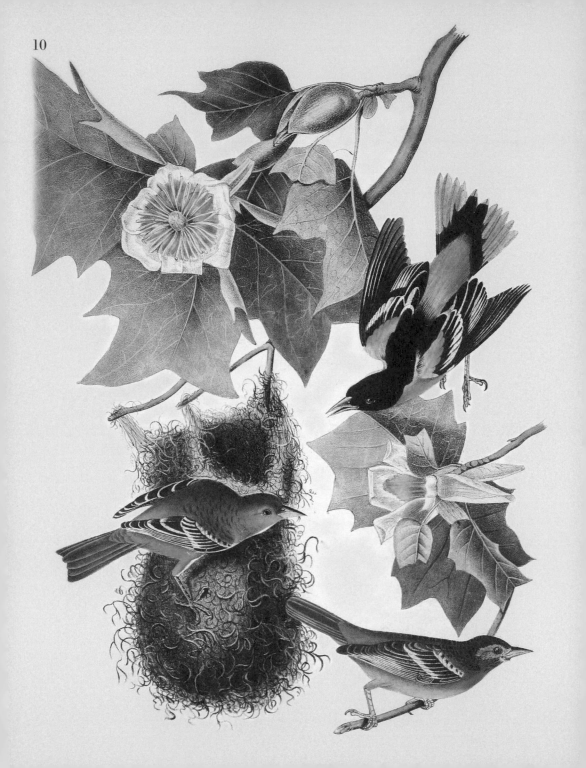

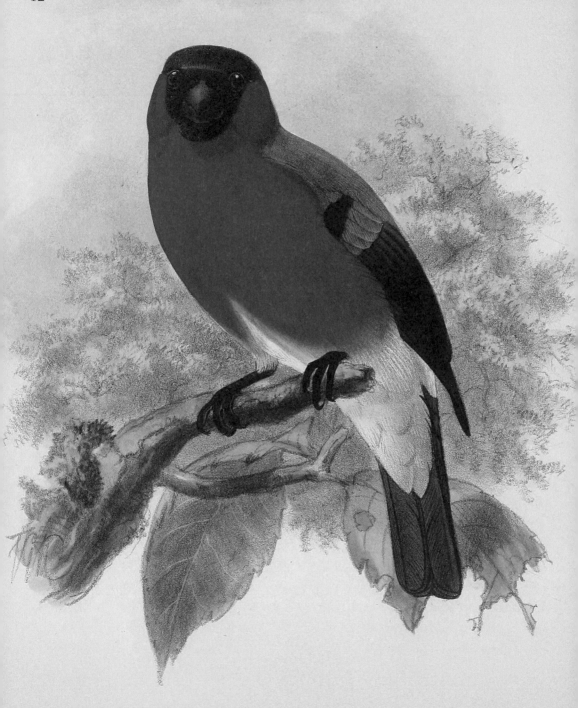

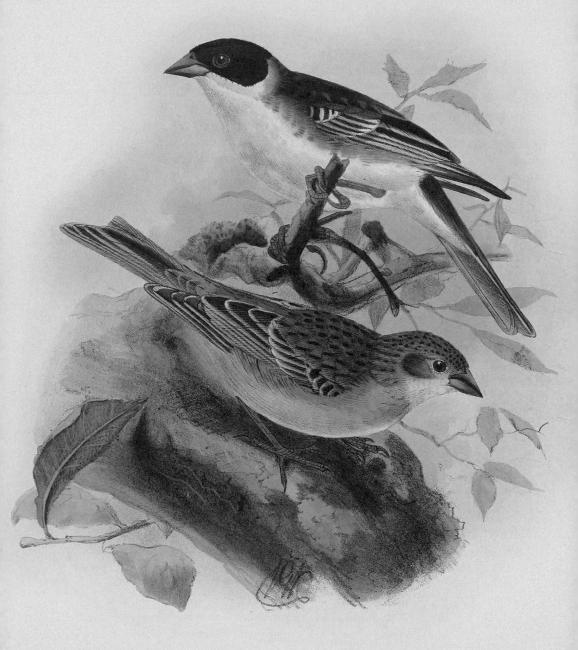

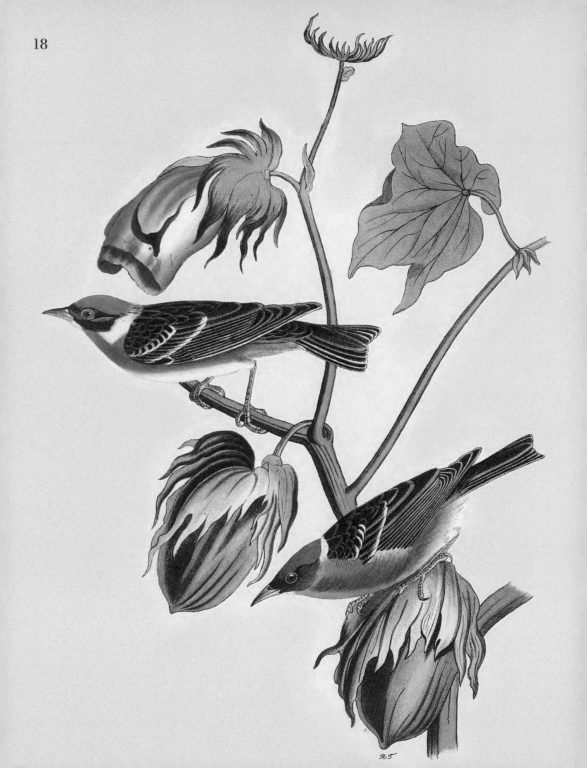

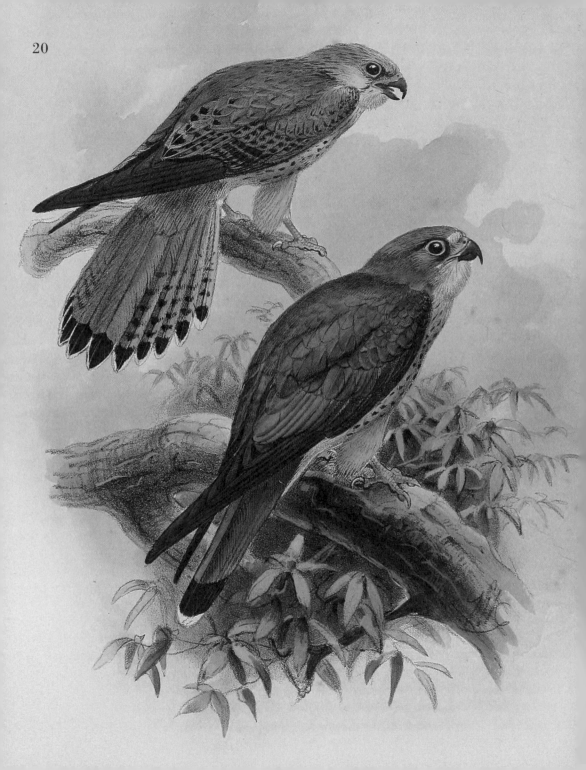

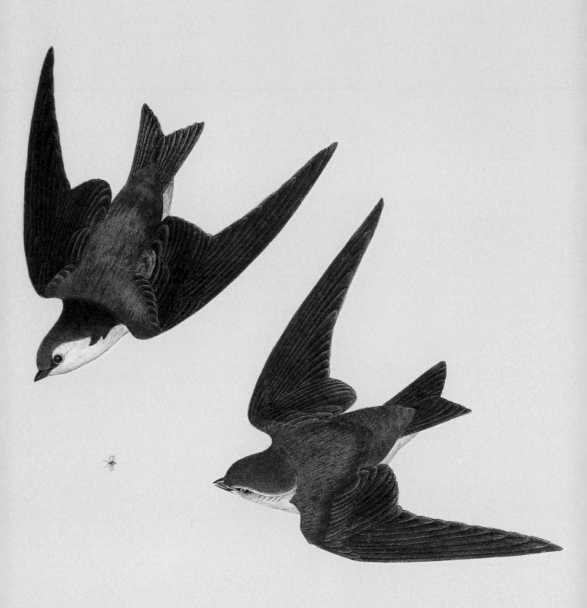

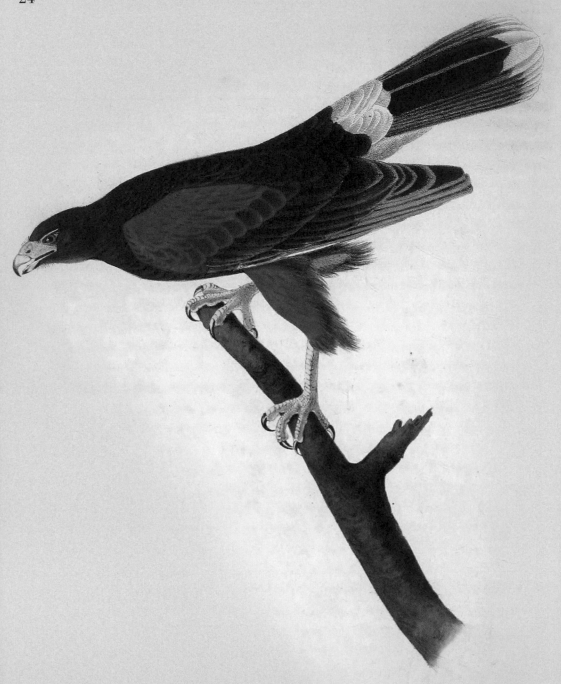

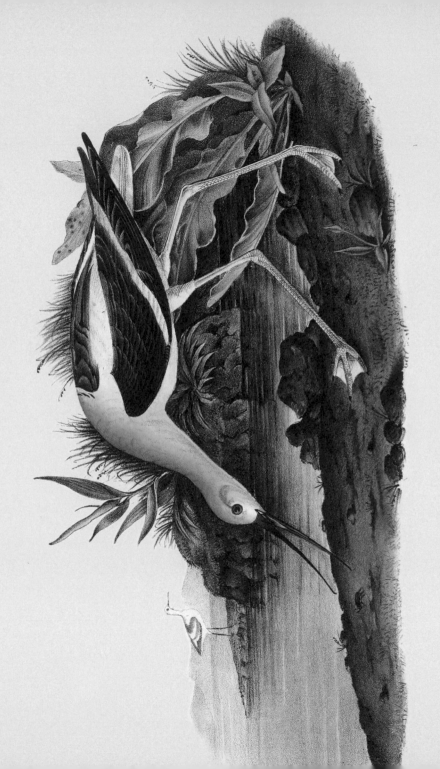

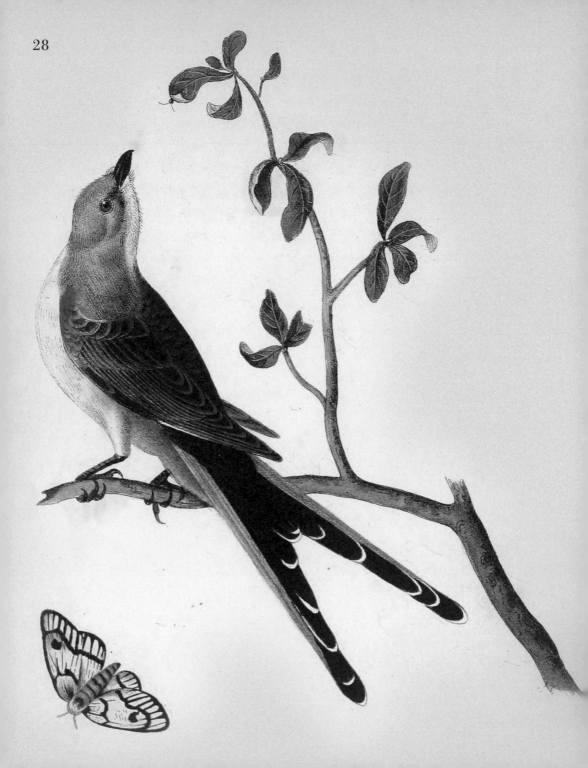

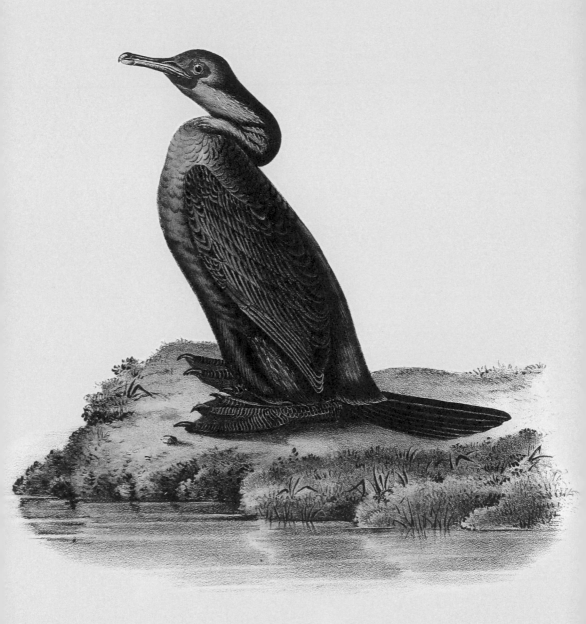

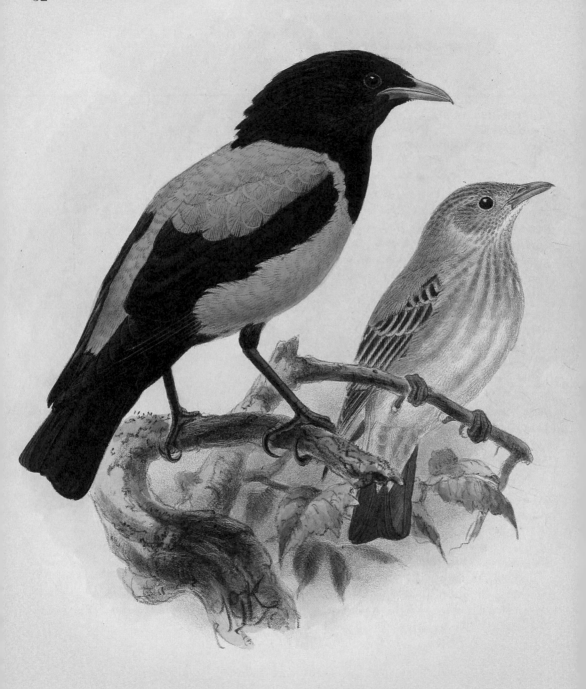

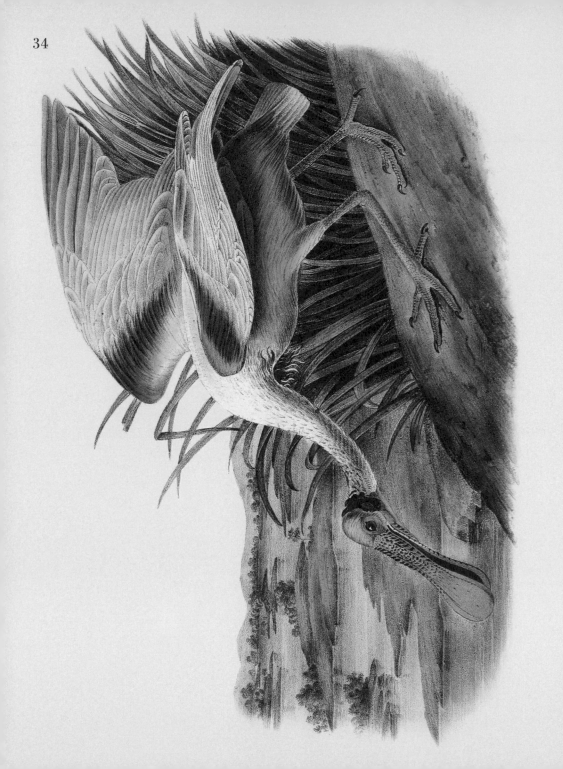

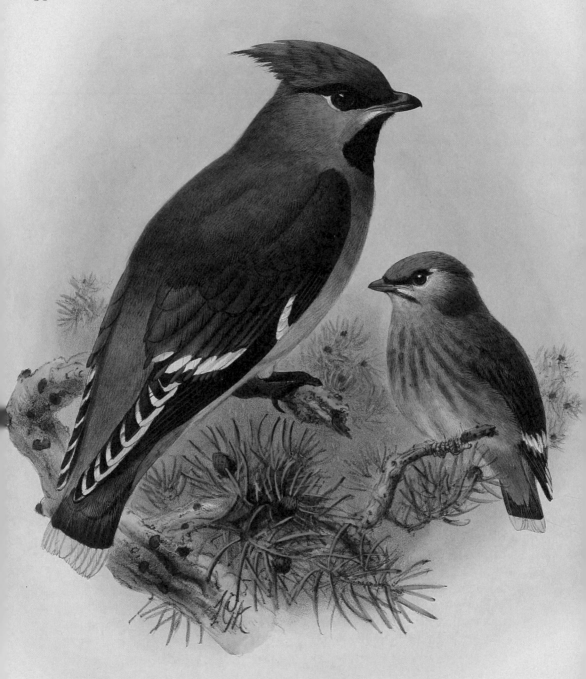

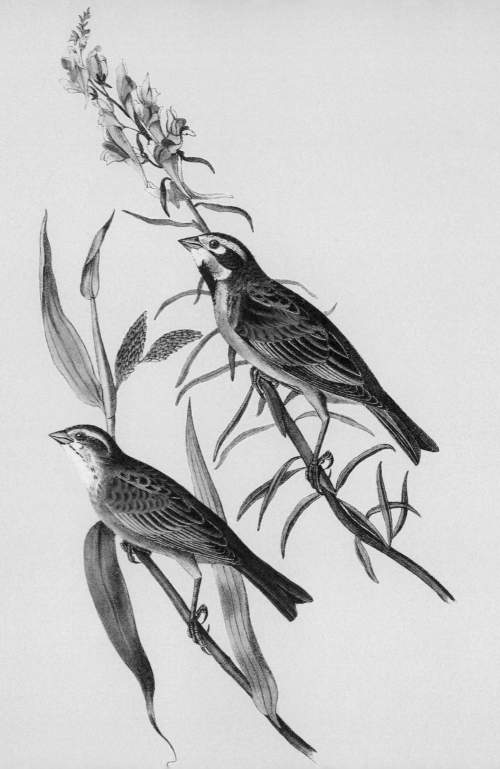

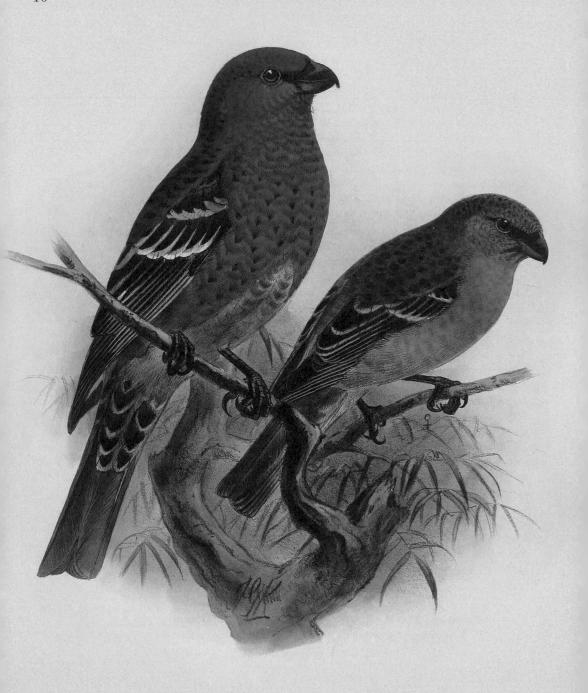

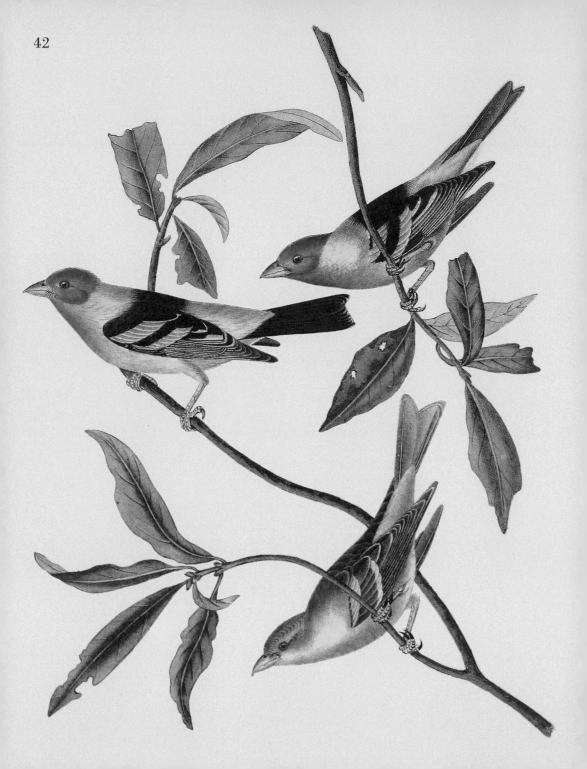

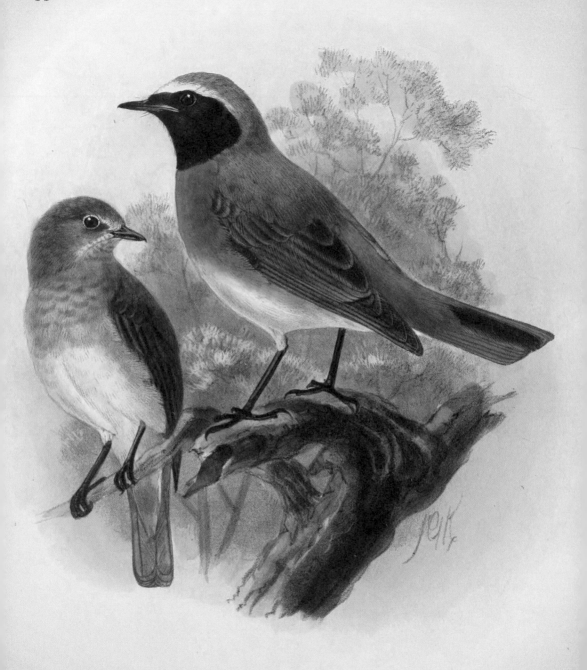

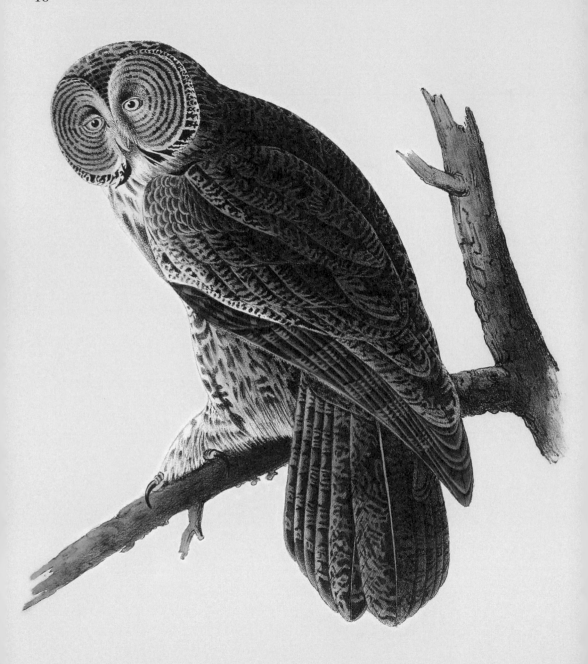

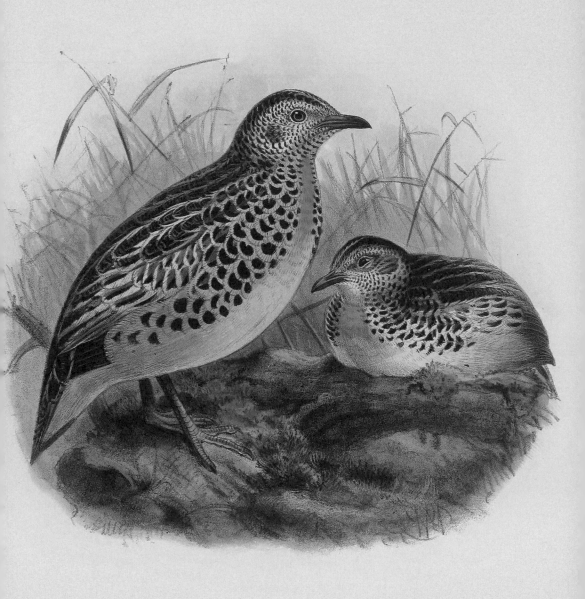

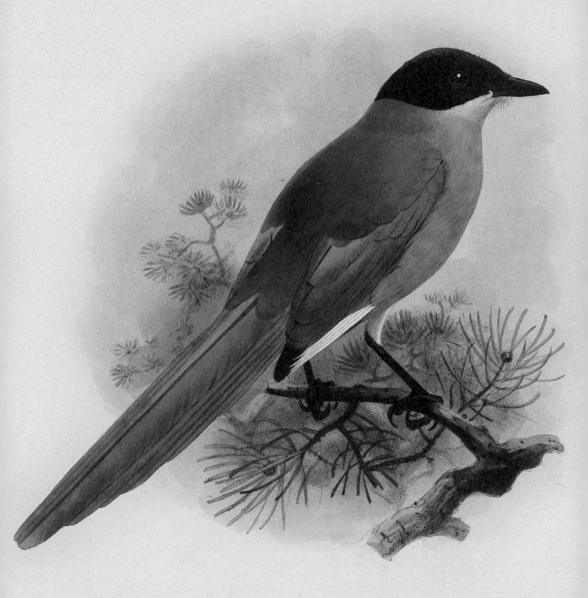

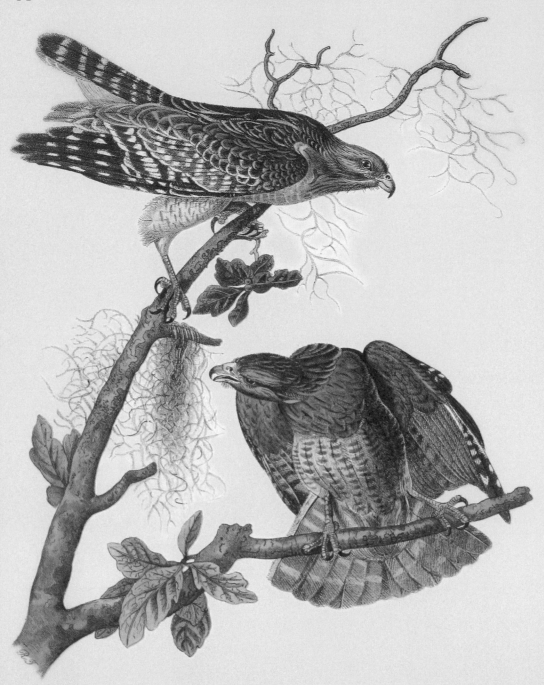

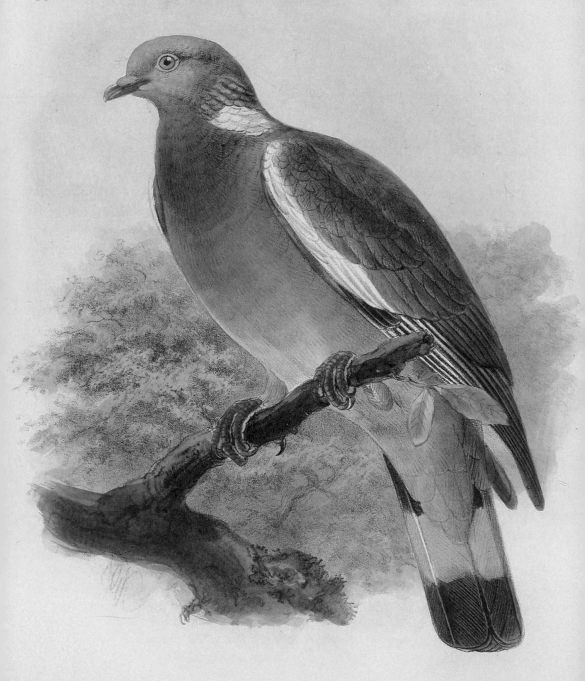

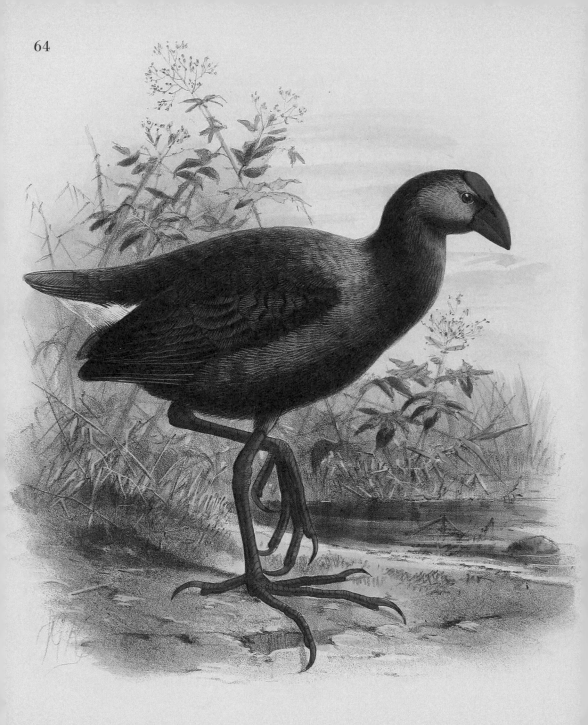

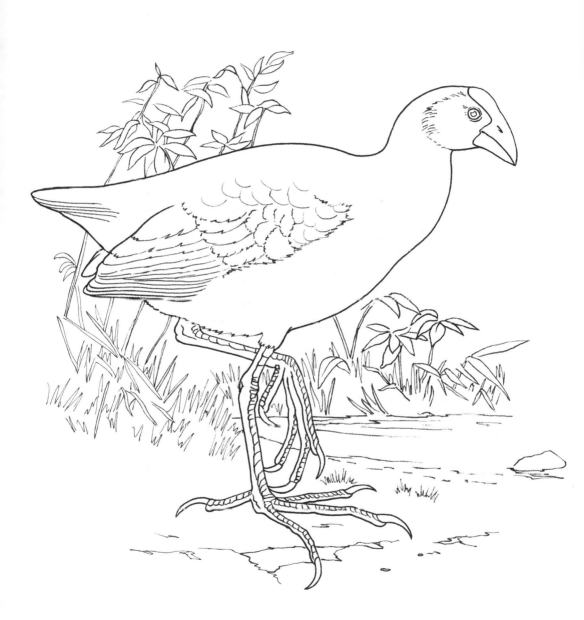

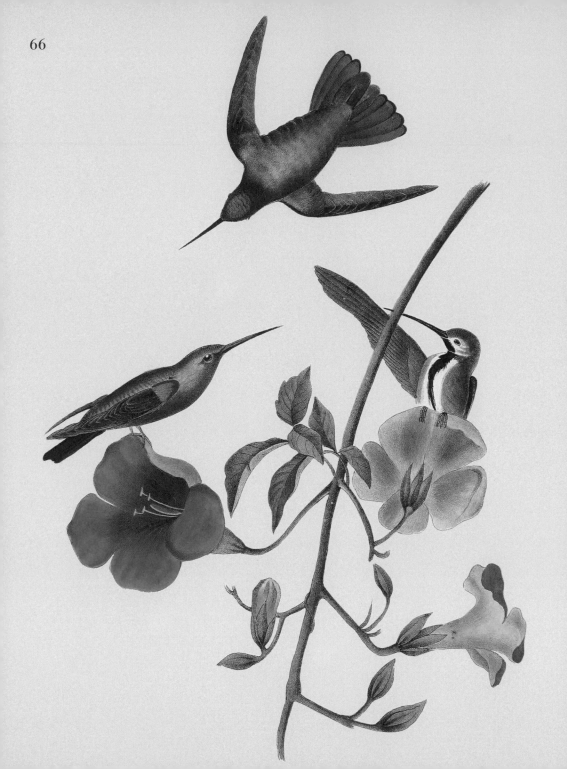

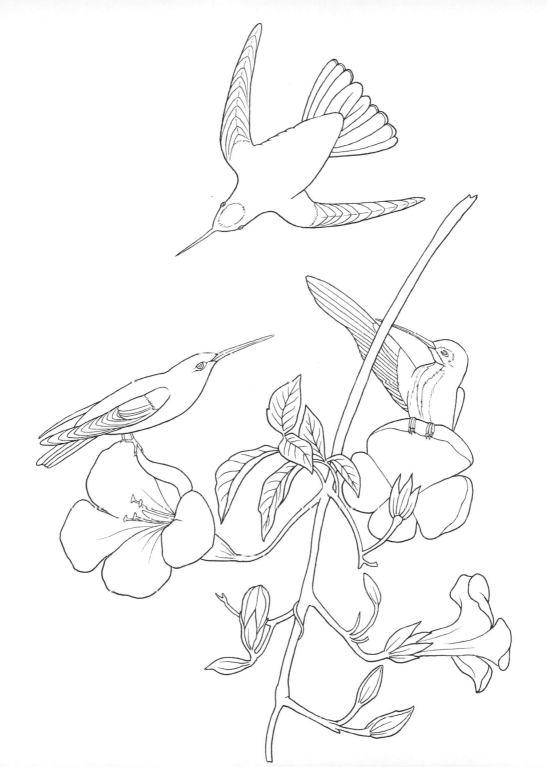

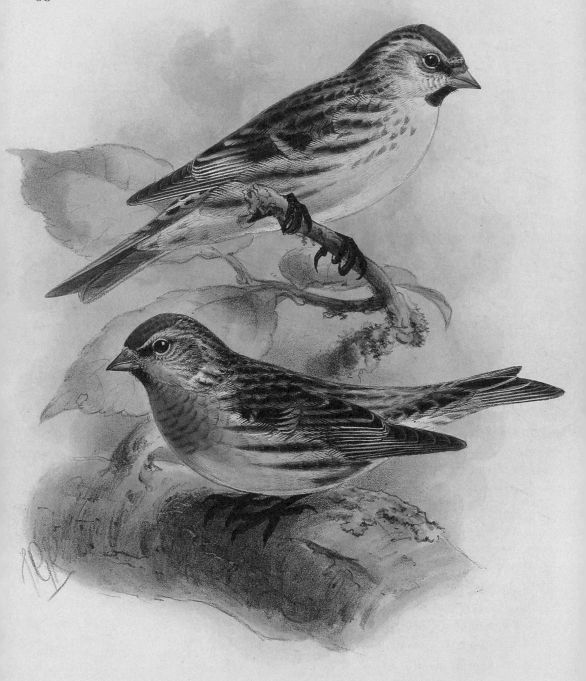

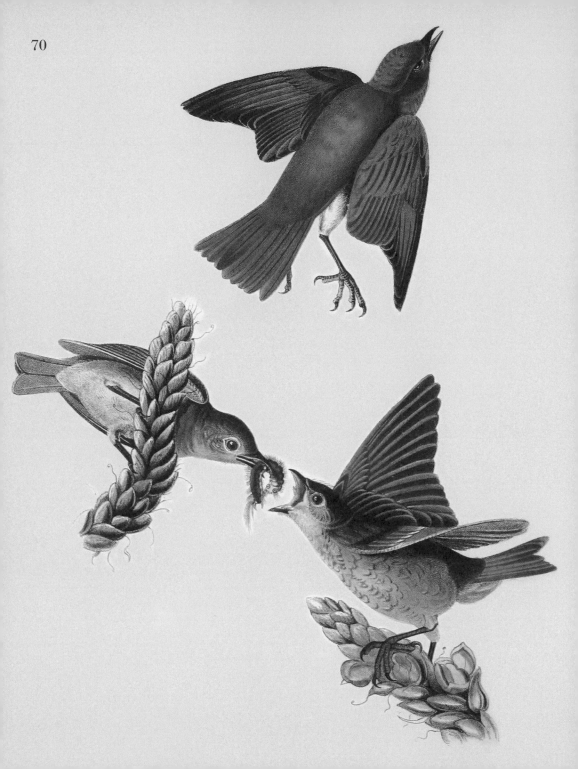

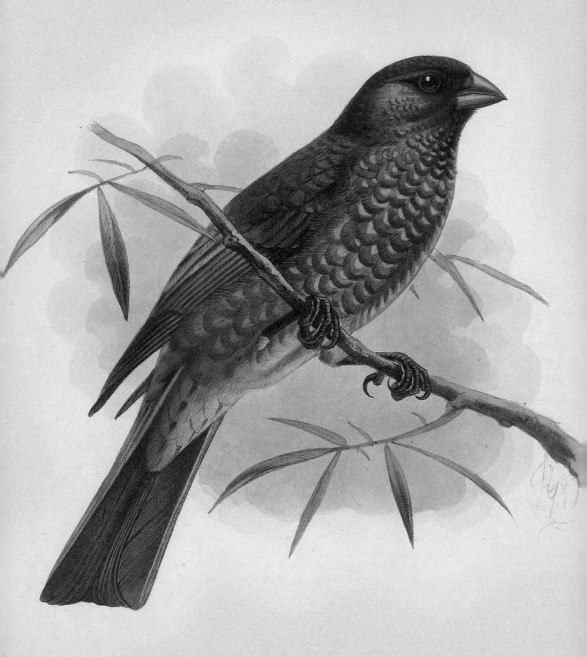

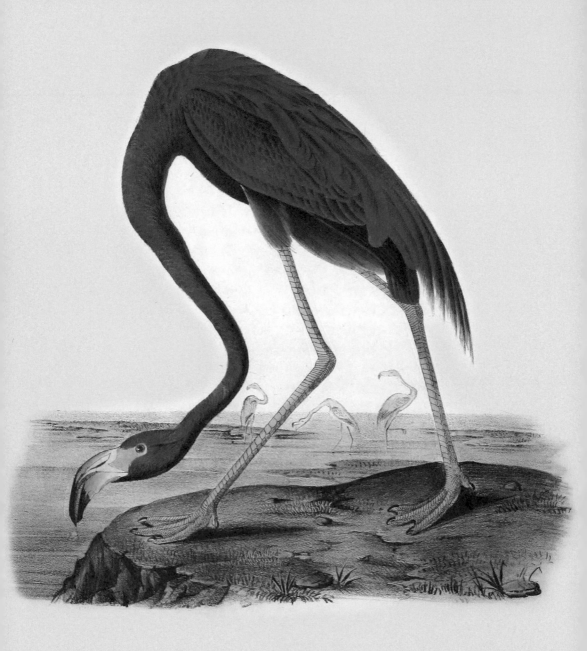

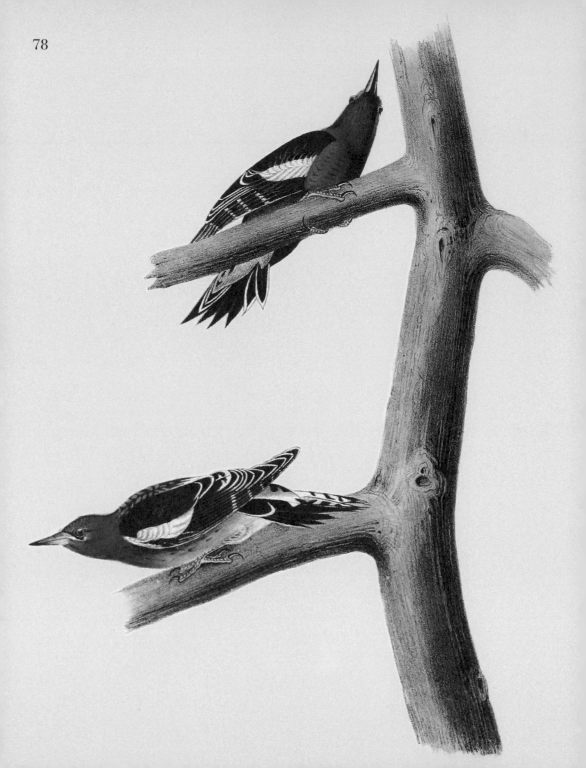

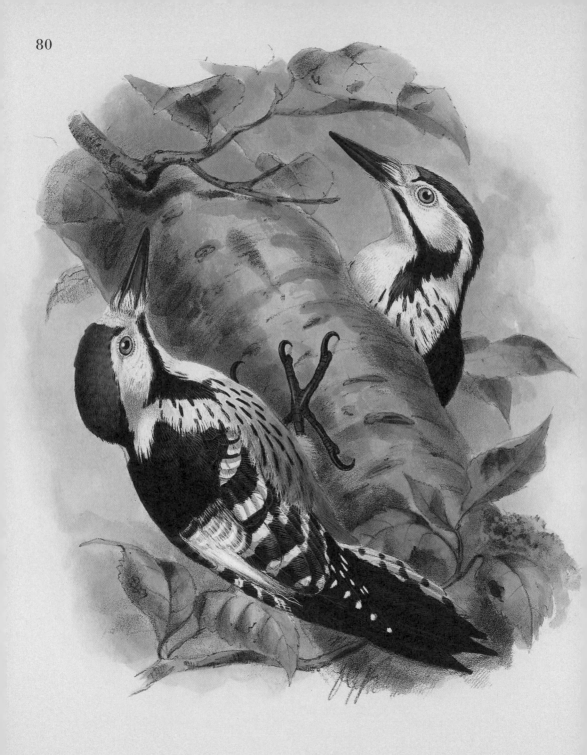

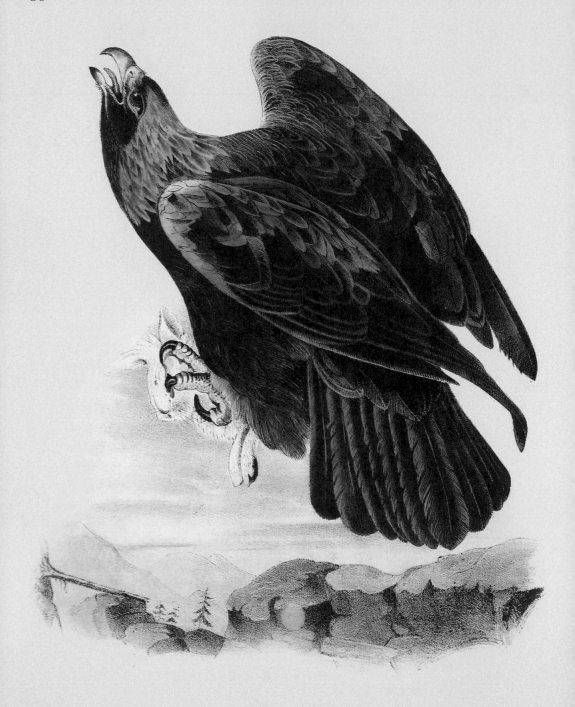

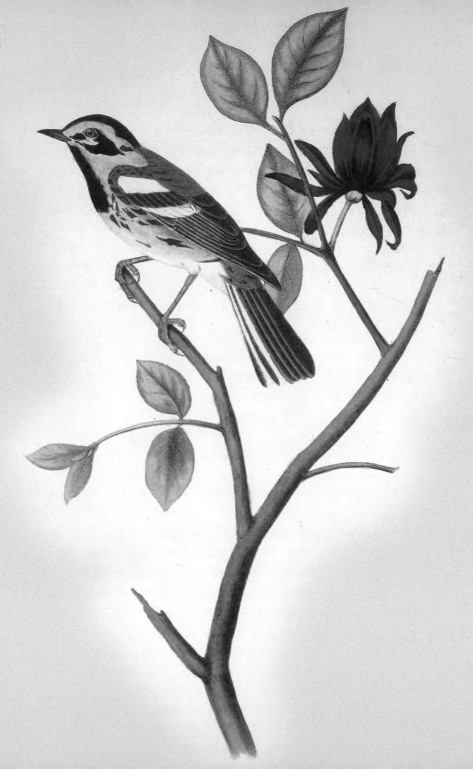

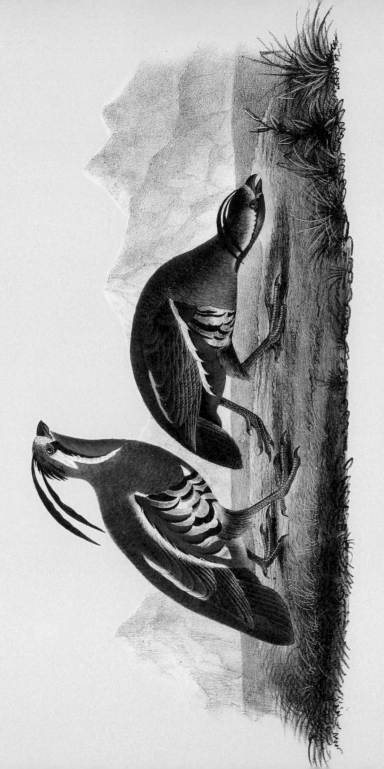

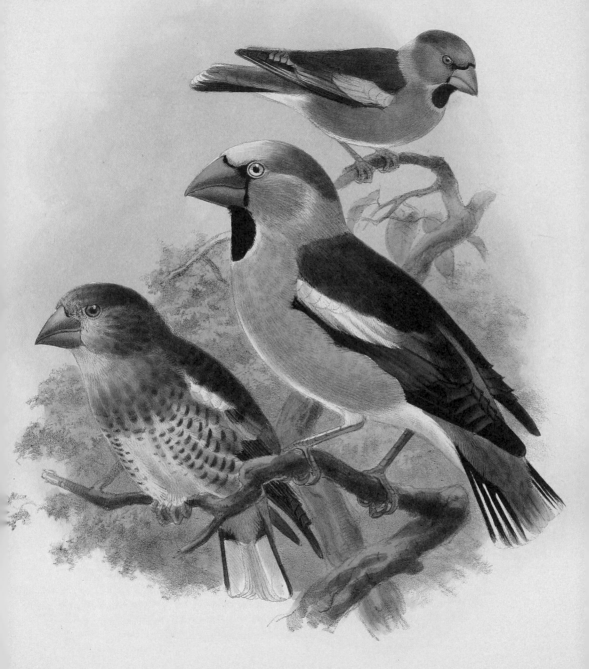

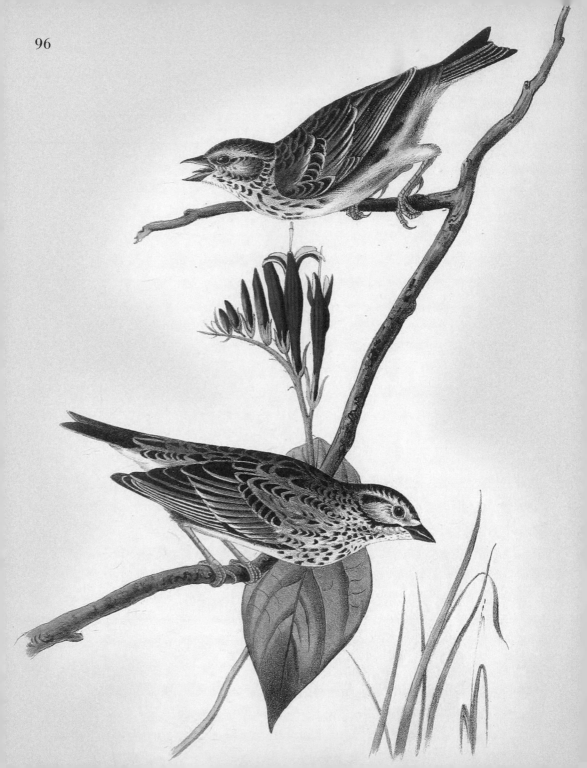

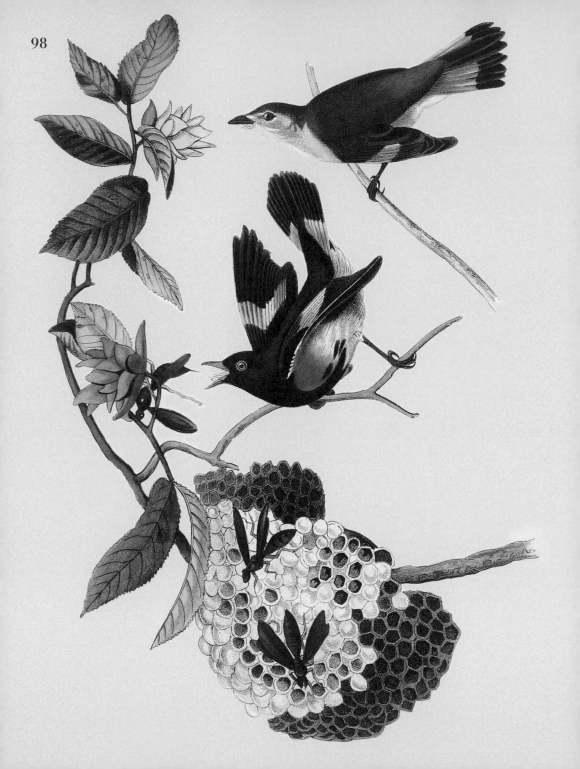

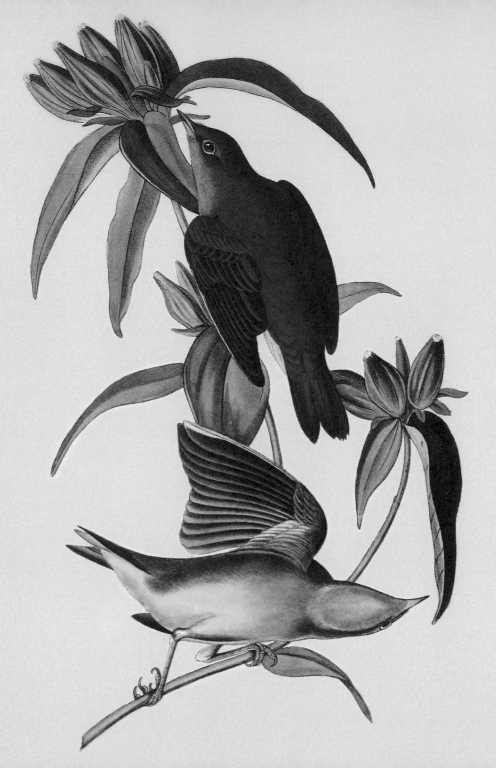

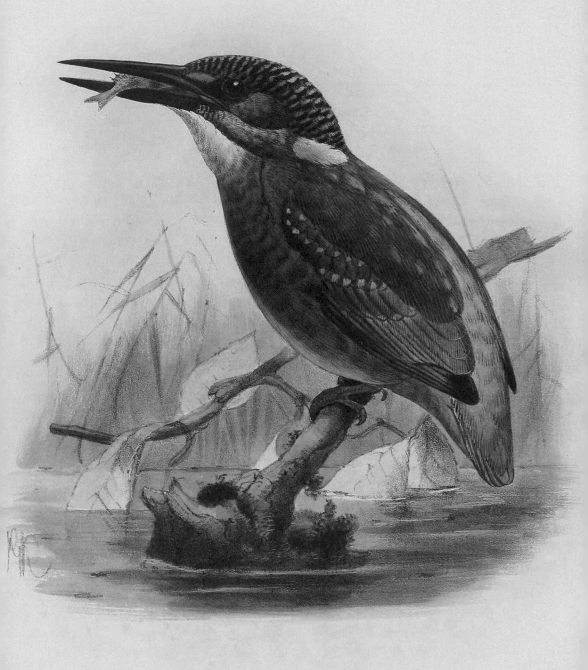

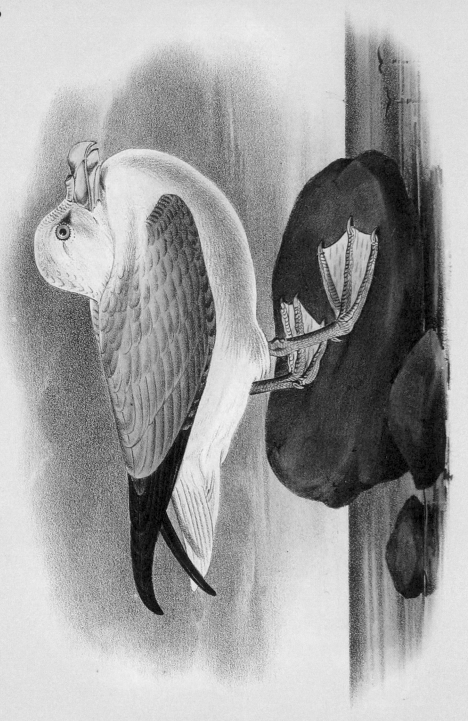

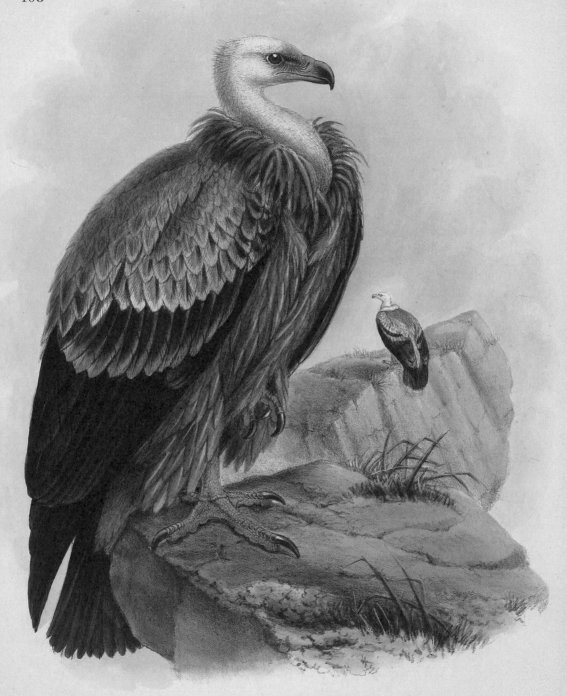

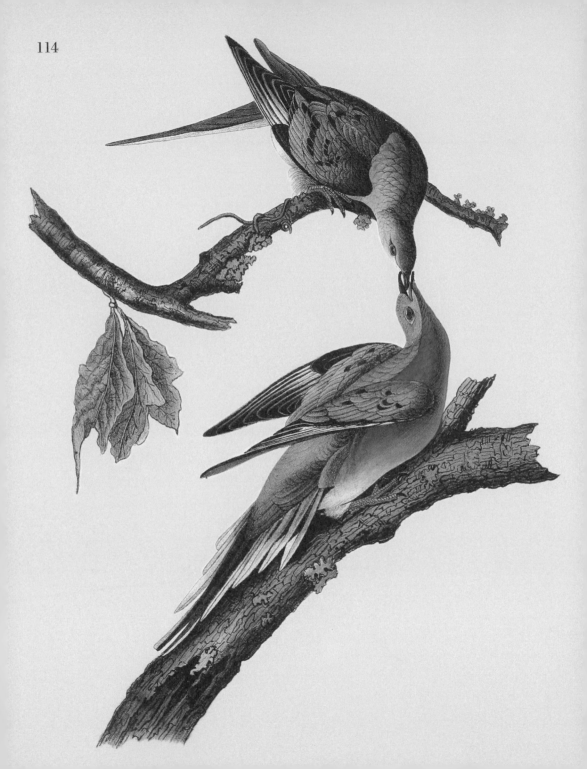

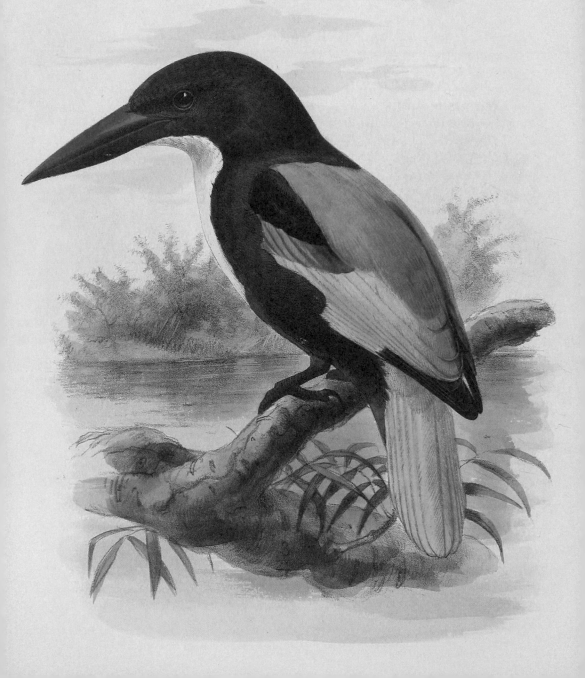

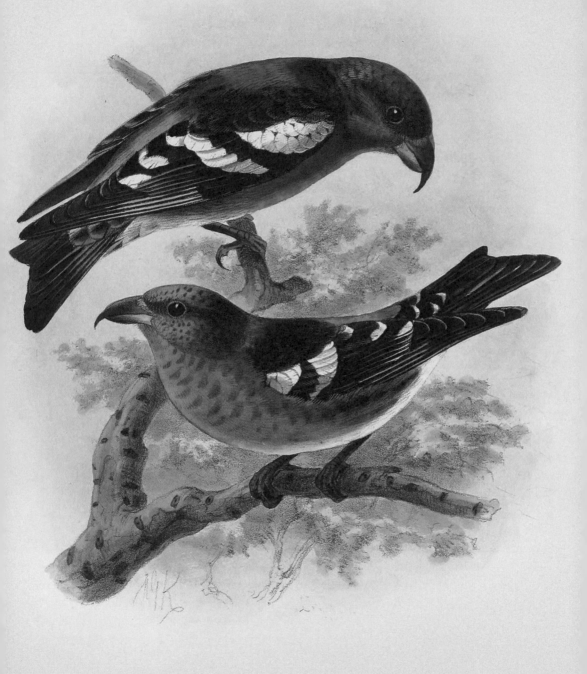

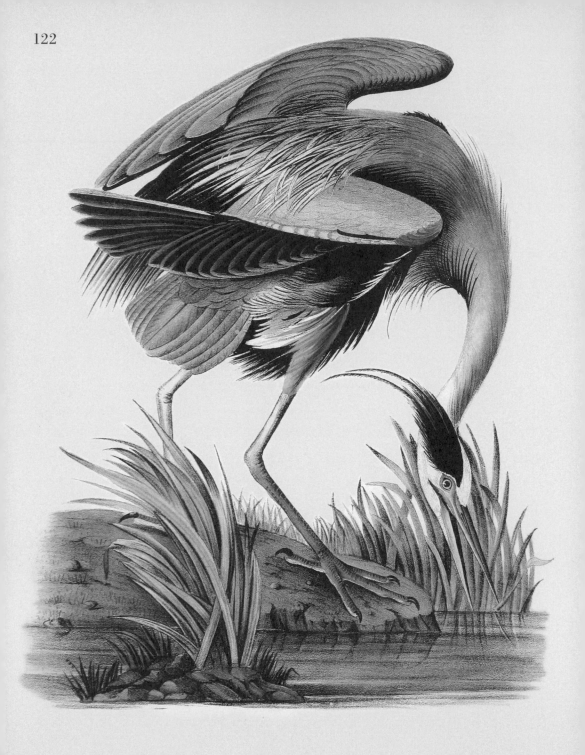

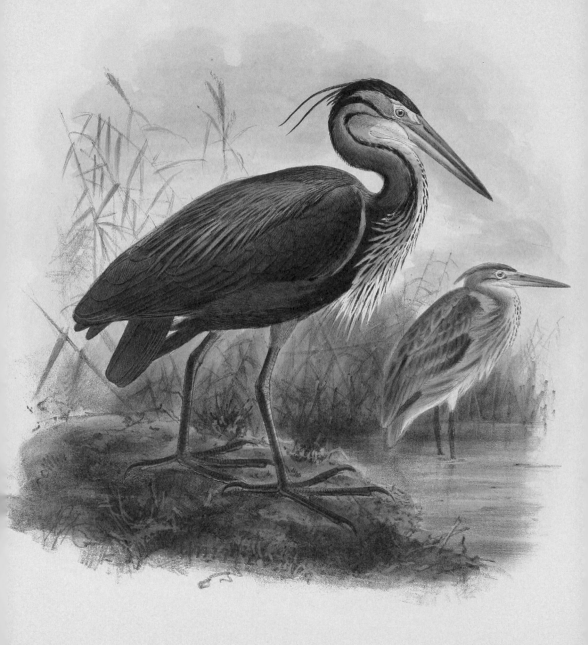

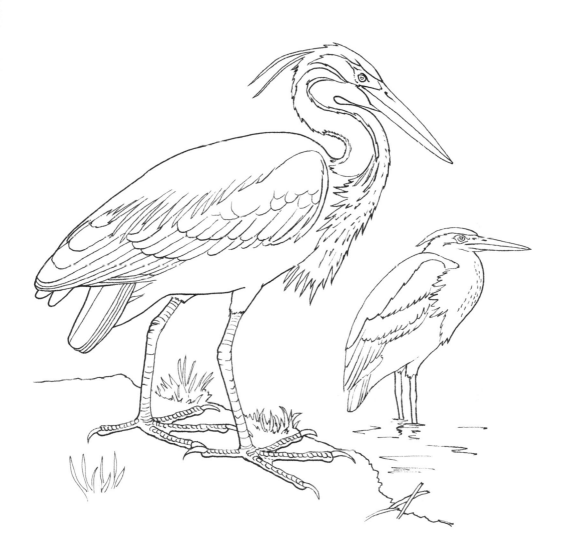

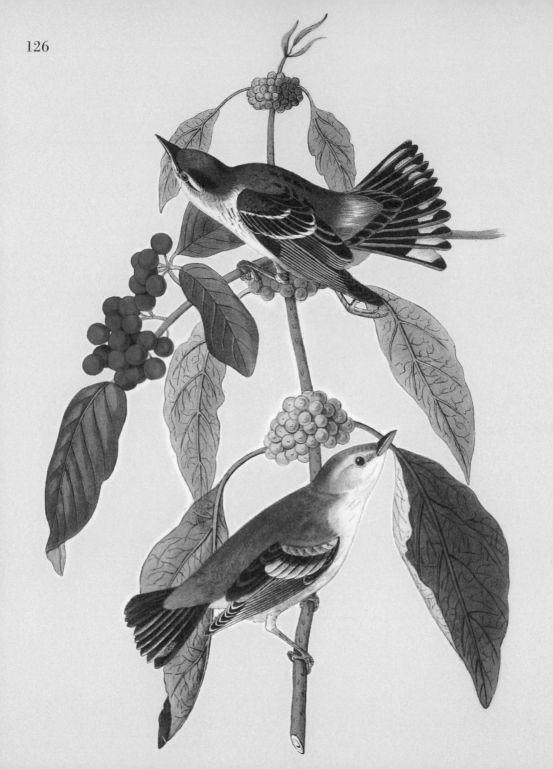

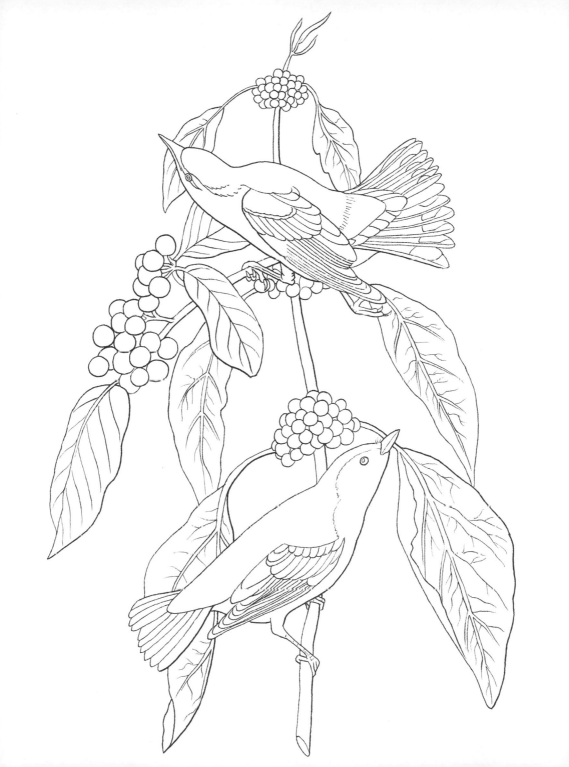

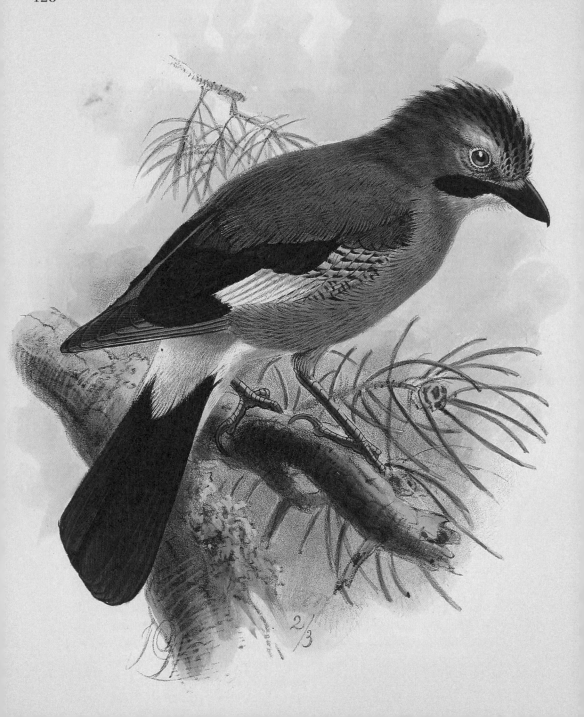

2/3

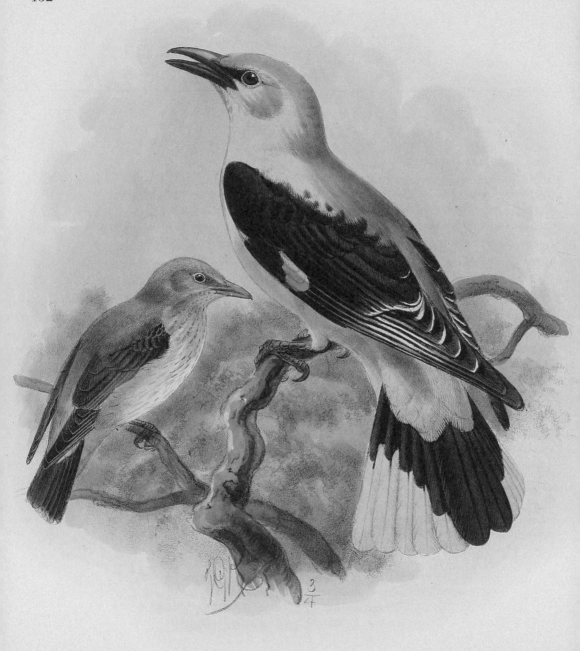

3/4

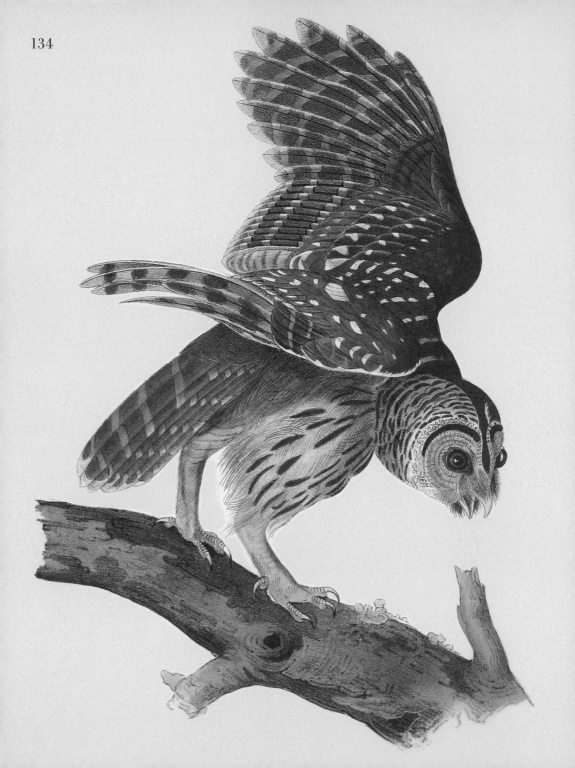

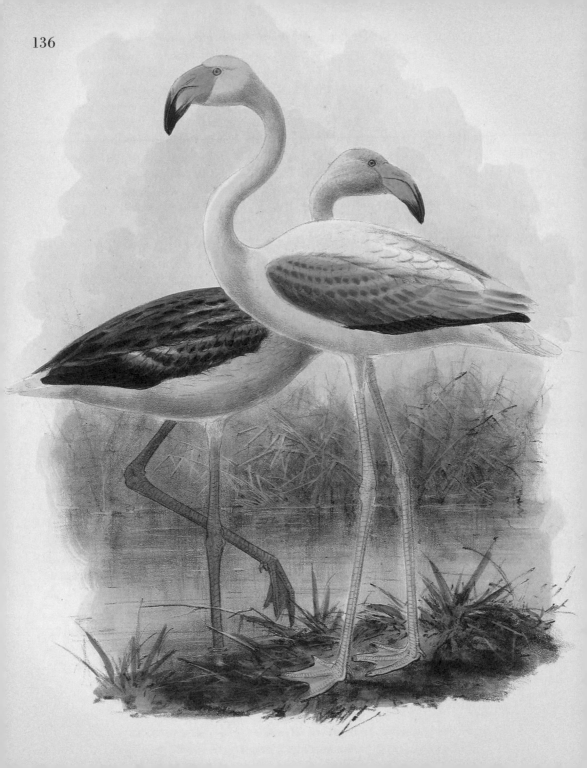

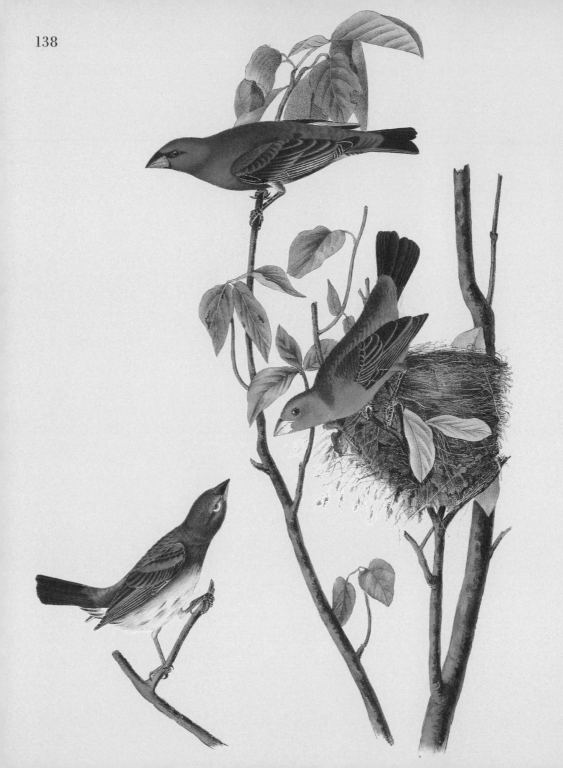

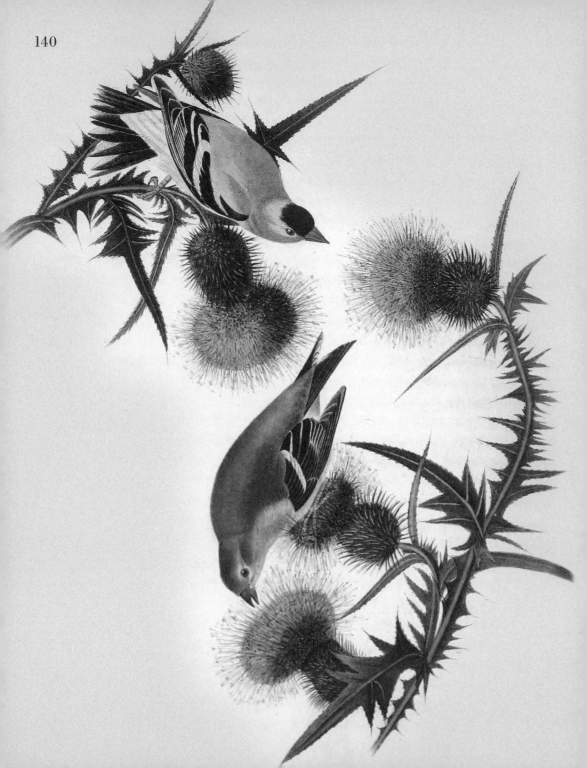

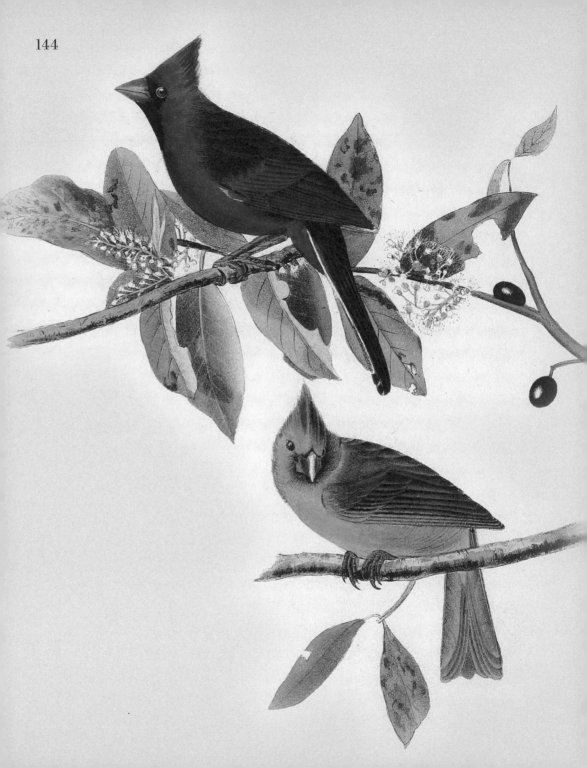

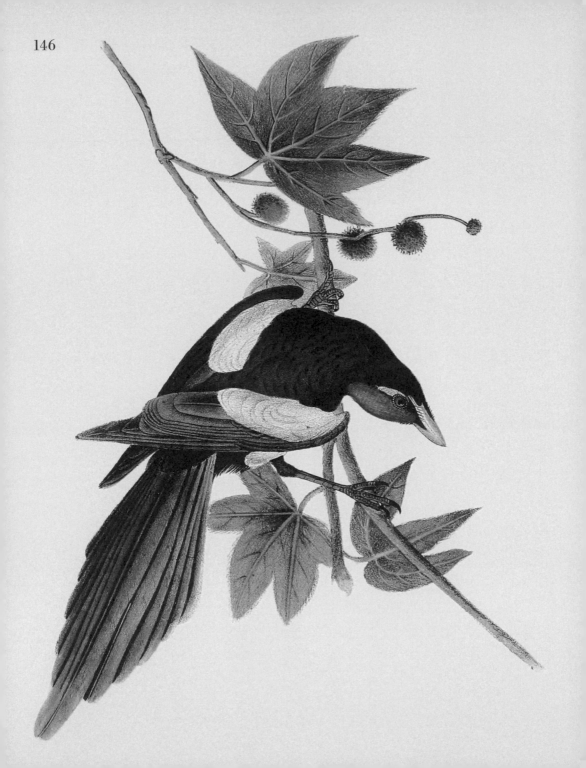

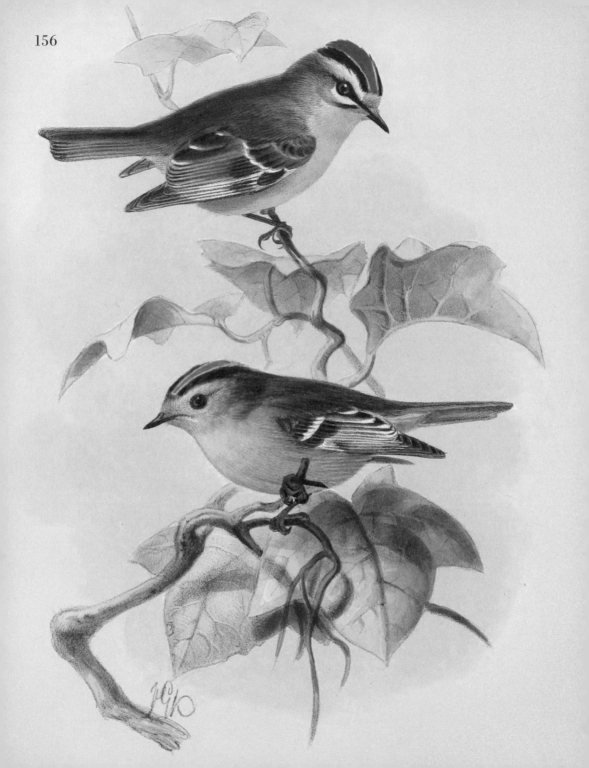

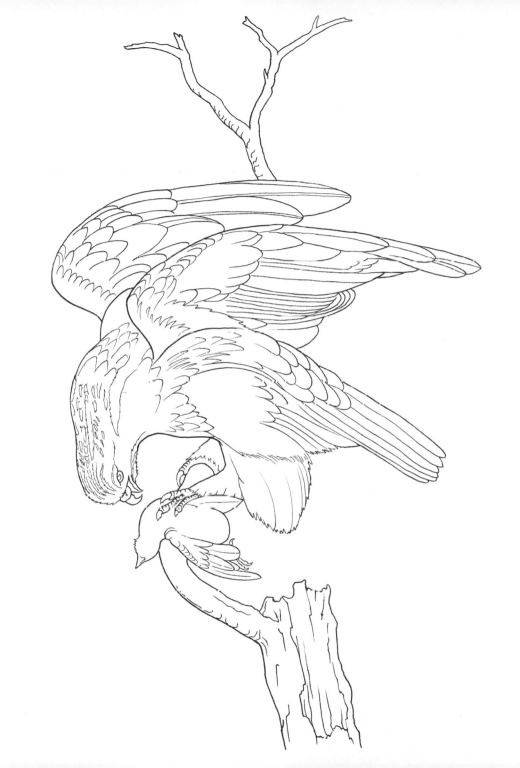

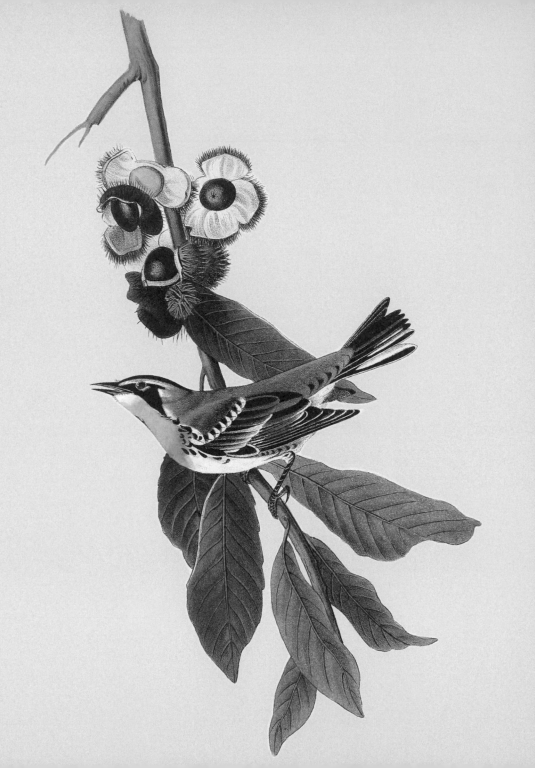